Tales from ATLANTIS

Hanna Karlzon

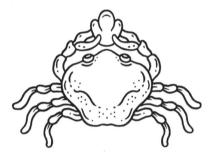

Tales from Atlantis Coloring Book Illustrations © 2023 Hanna Karlzon

Original title: Berättelser från Atlantis

Copyright © Hanna Karlzon och Tukan förlag 2023 Illustrations and design: Hanna Karlzon www.hannakarlzon.com

First published by Tukan förlag 2023 Örlogsvägen 15 426 71 Västra Frölunda Sweden www.tukanforlag.se

English edition copyright © 2024 Gibbs Smith Publisher, USA.

All rights reserved. No part of this book may be reproduced by any means whatsoever without written permission from the publisher, except brief portions quoted for purpose of review.

Gibbs Smith P.O. Box 667 Layton, Utah 84041

1.800.835.4993 orders www.gibbs-smith.com

ISBN: 978-1-4236-6547-2

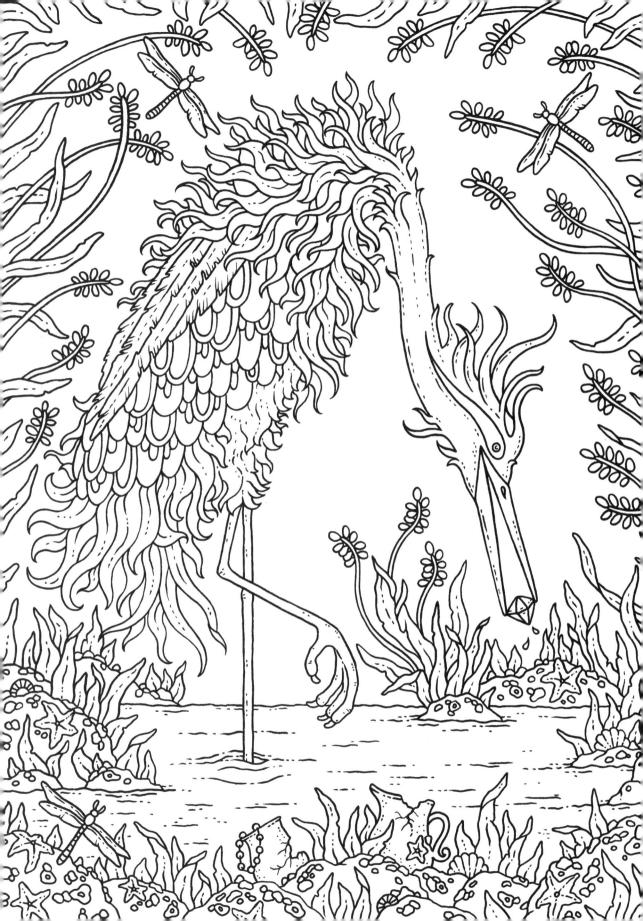

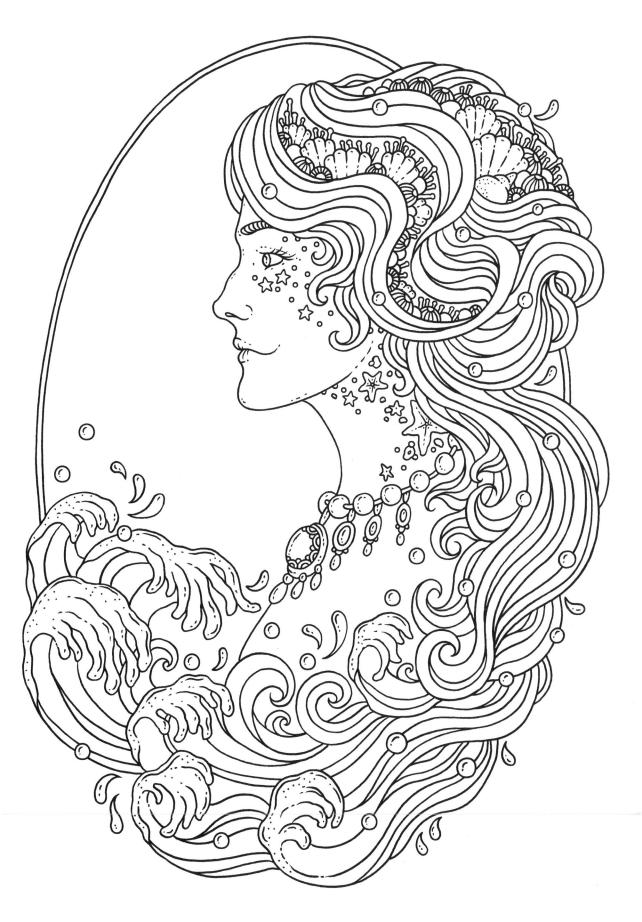

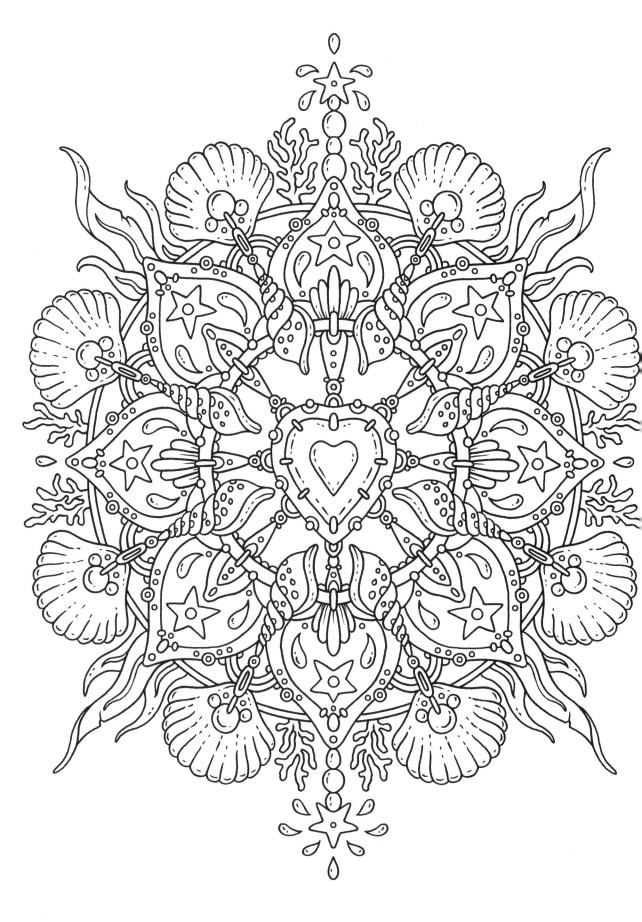

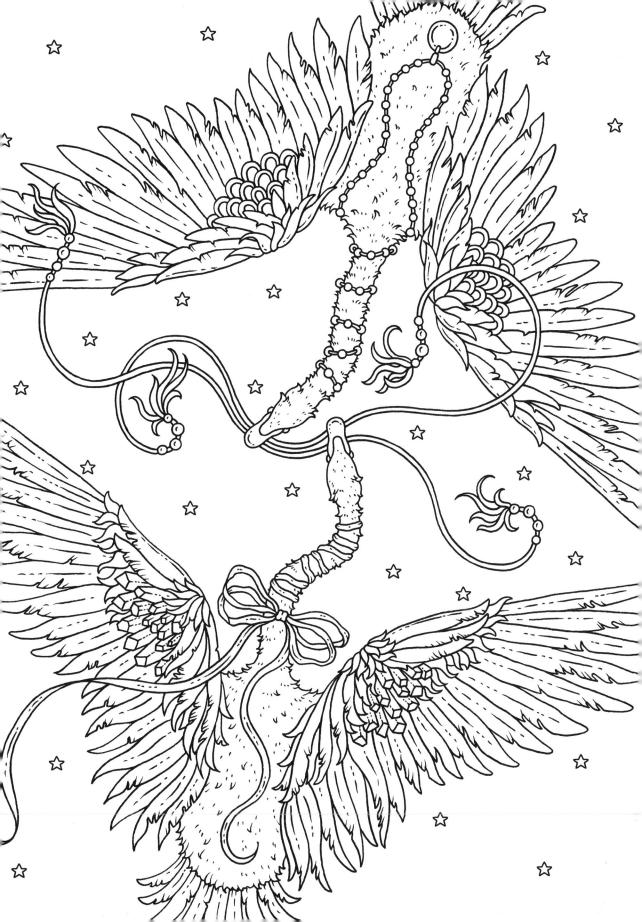

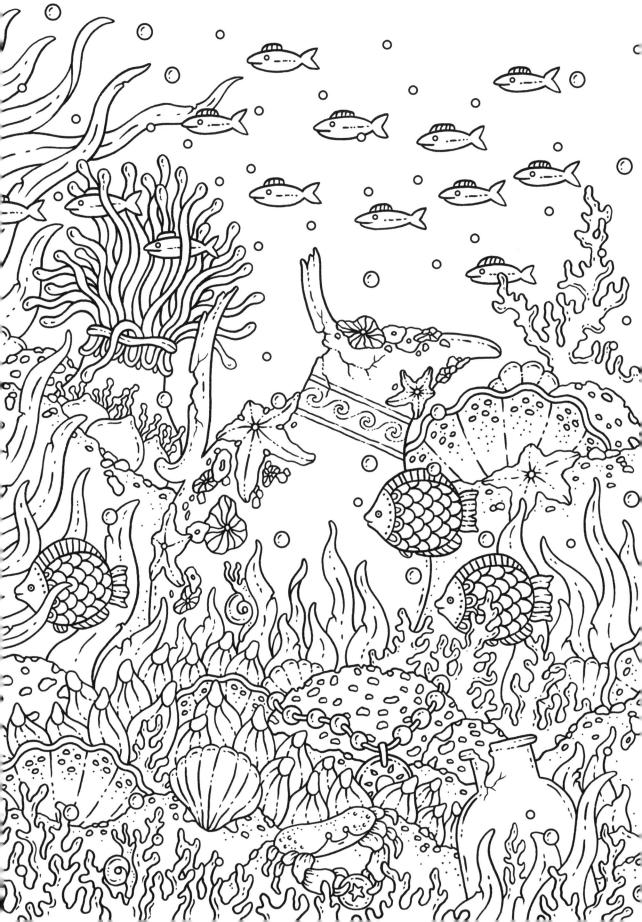

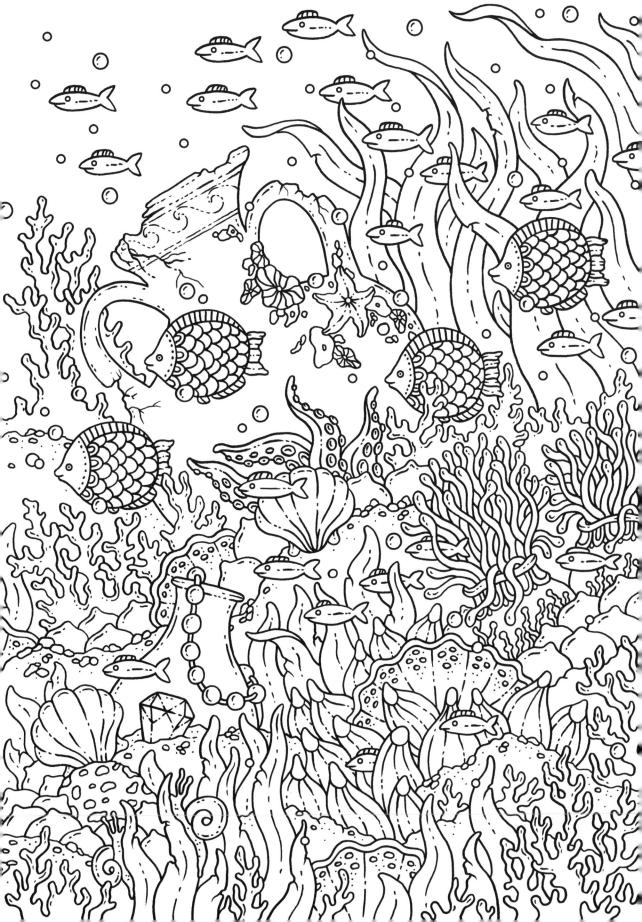

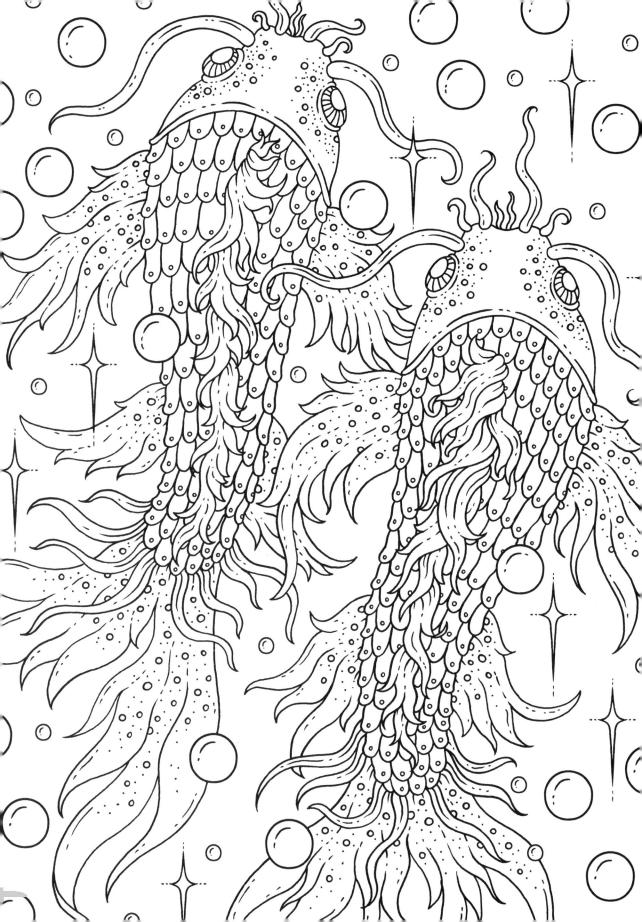

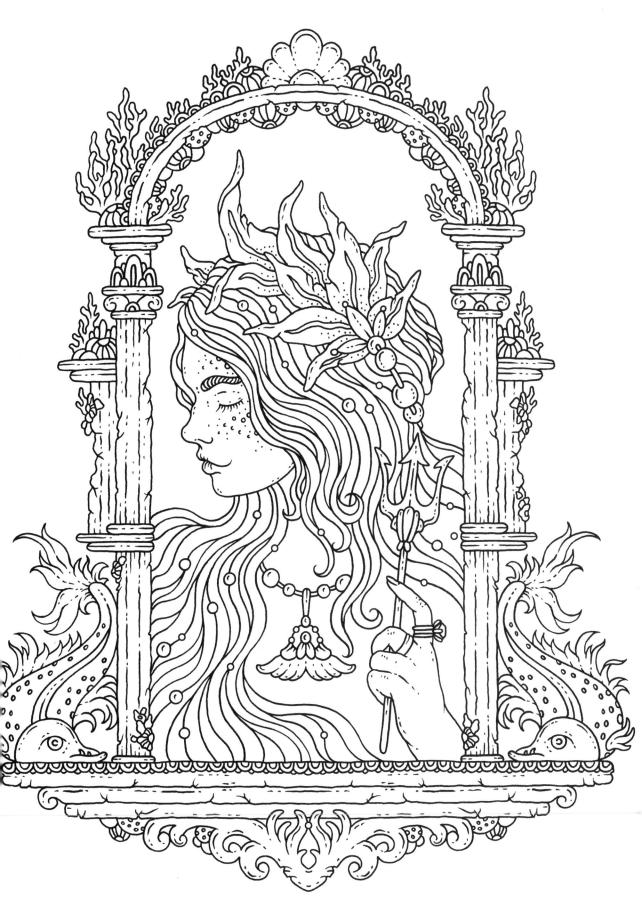

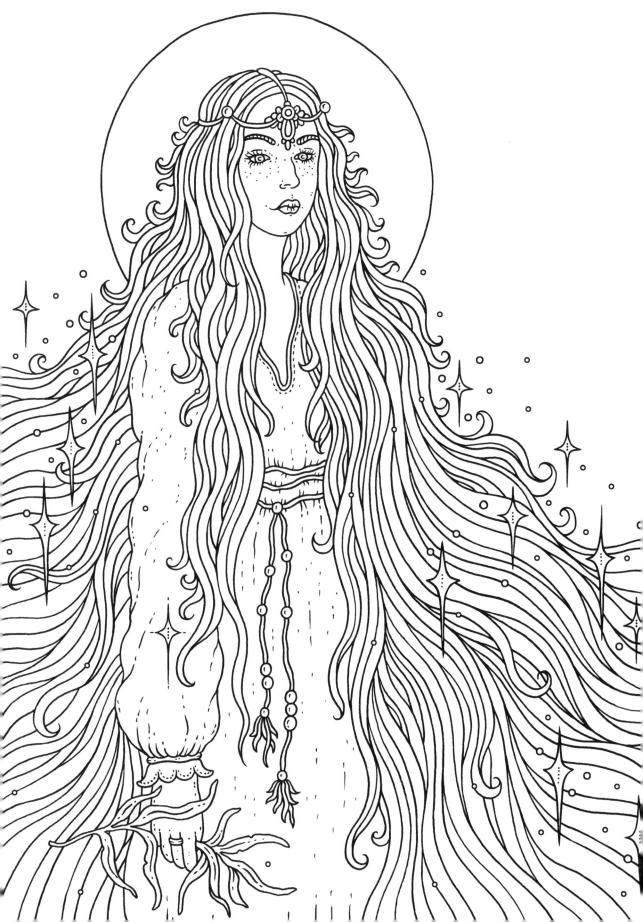

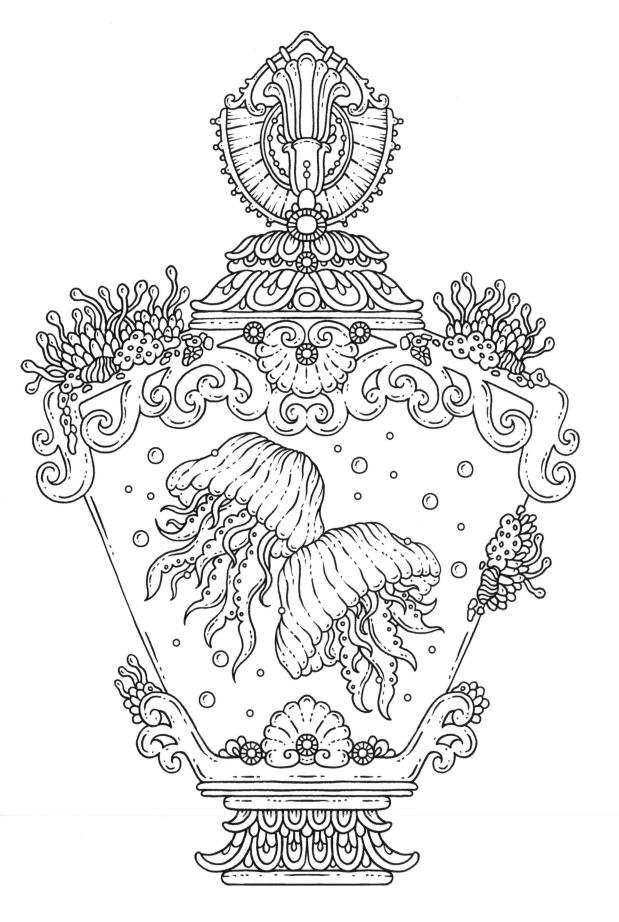

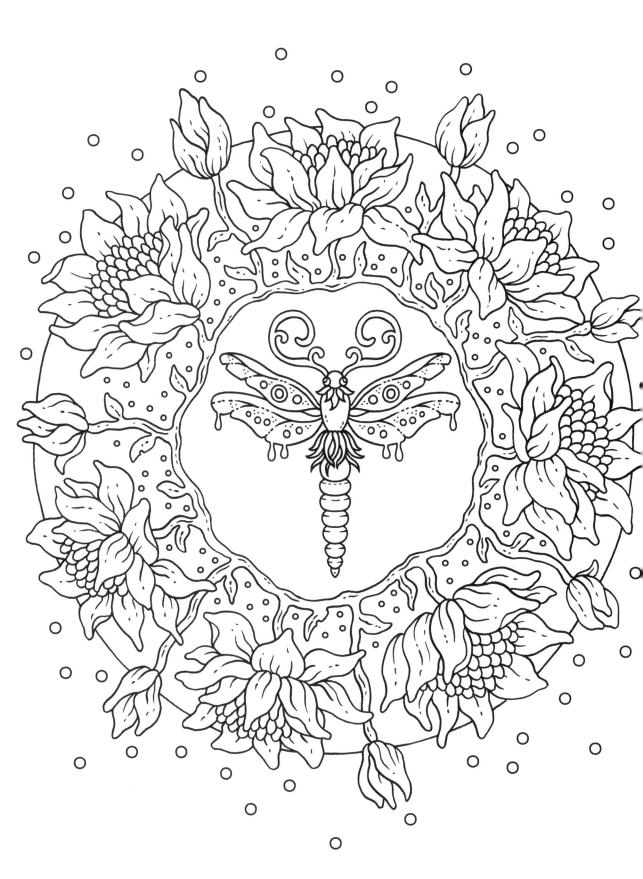

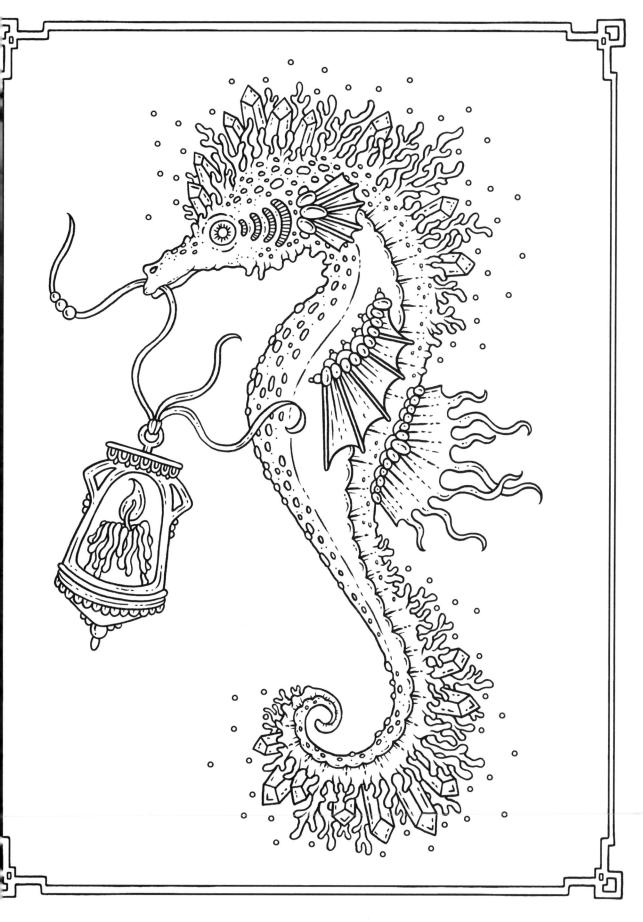

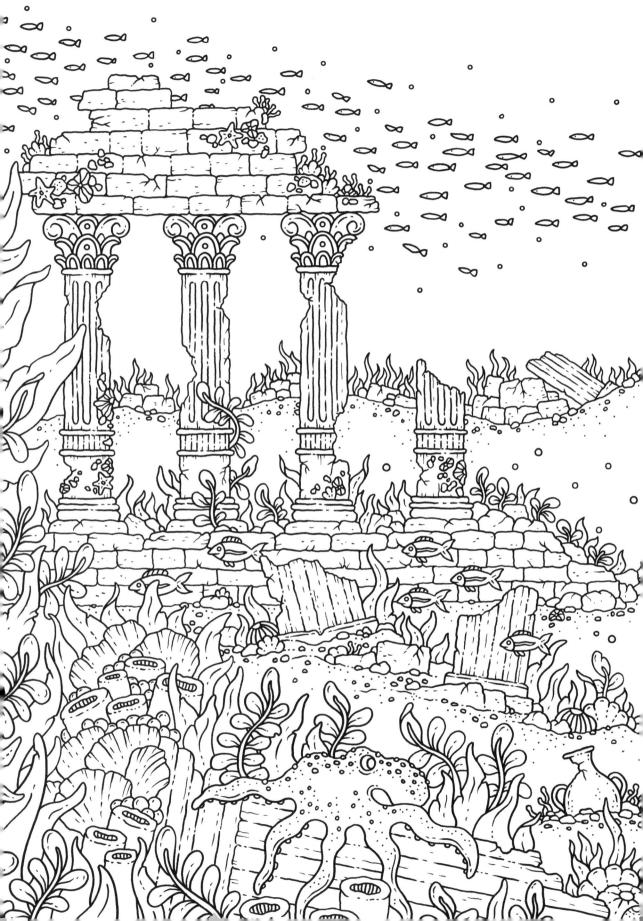

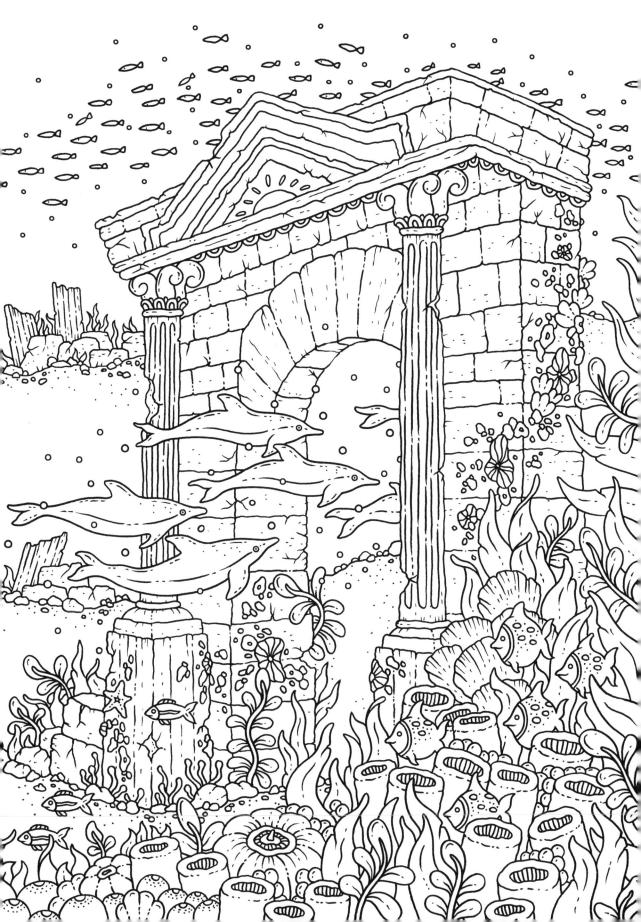

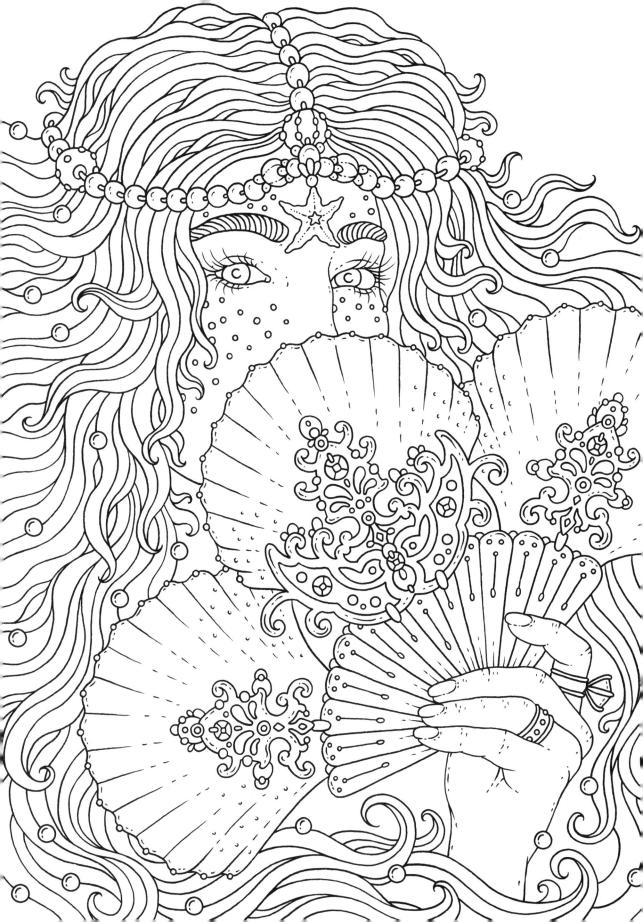

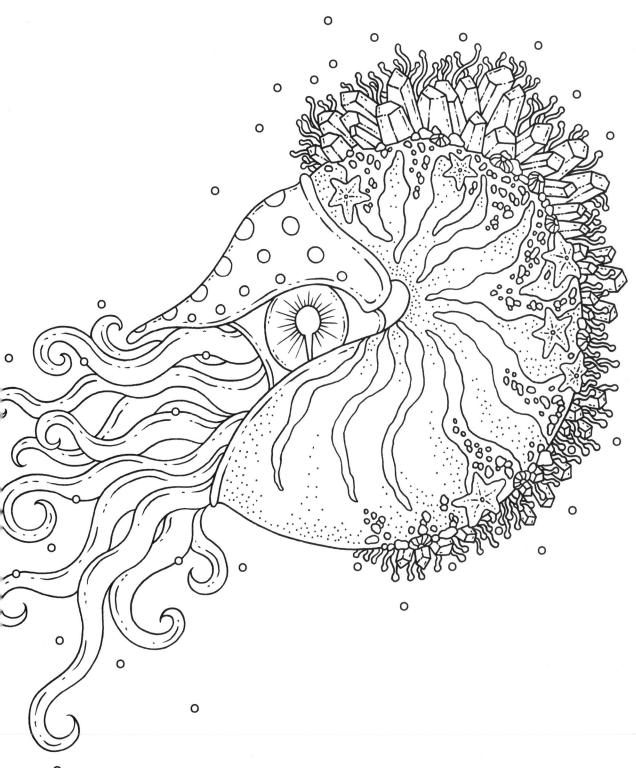

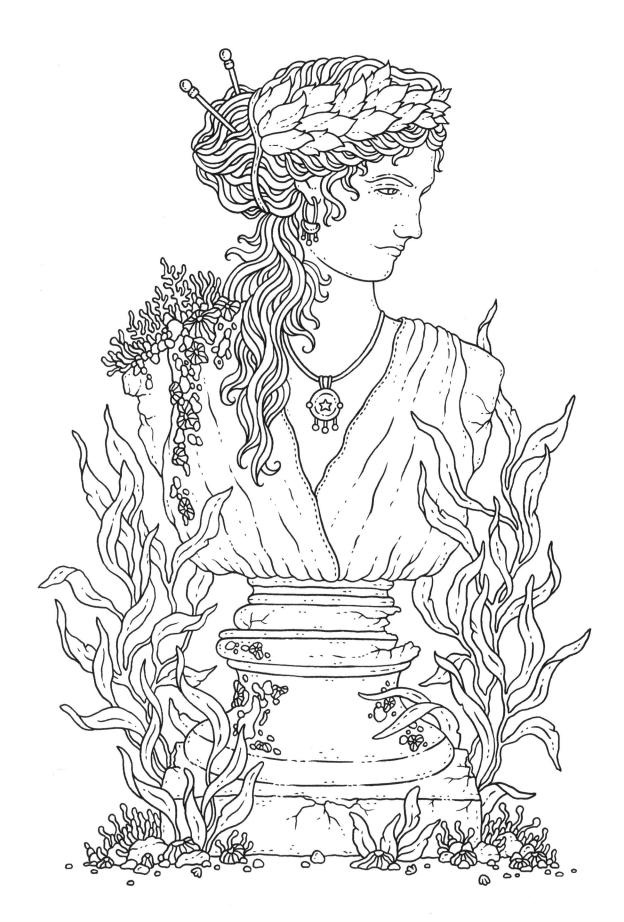

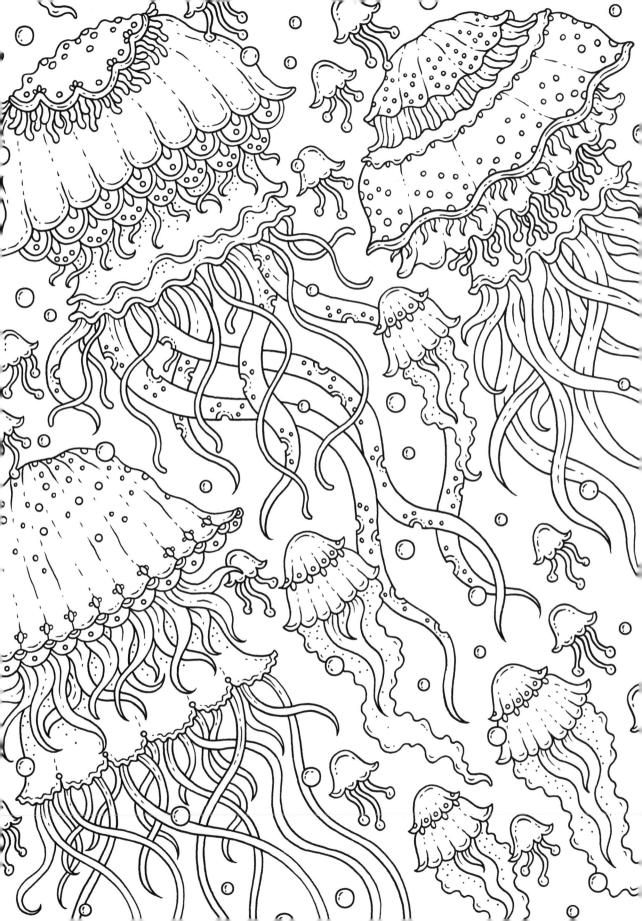

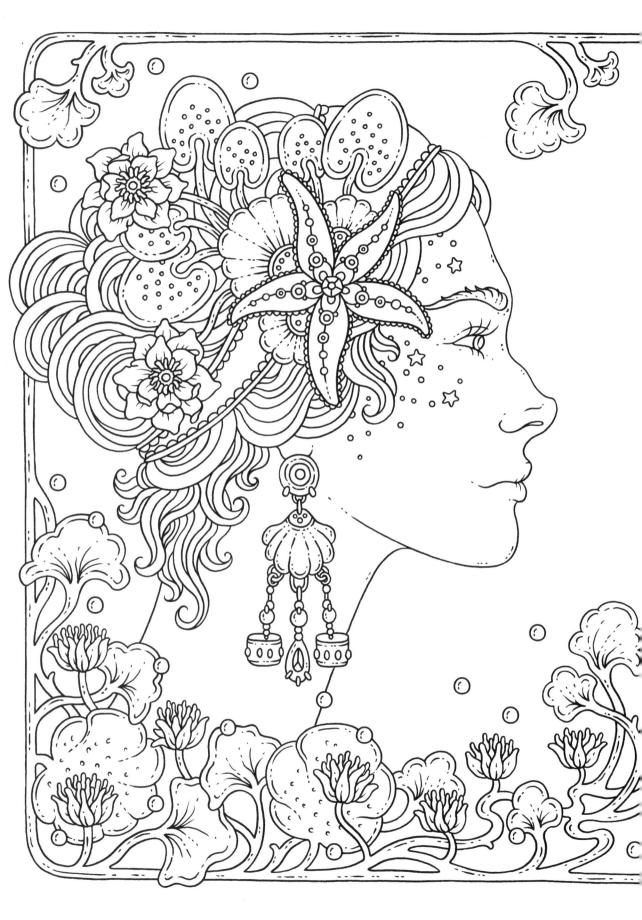

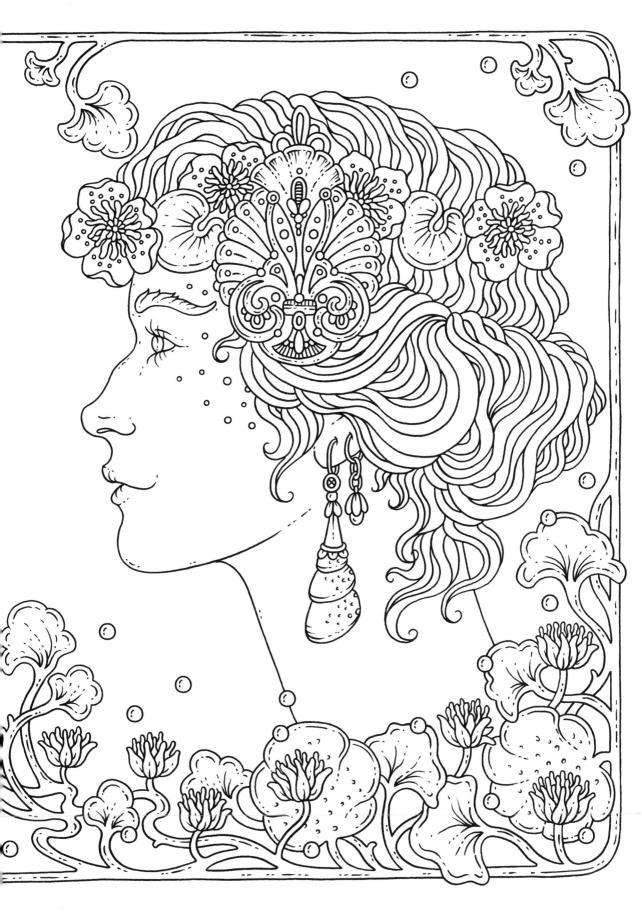

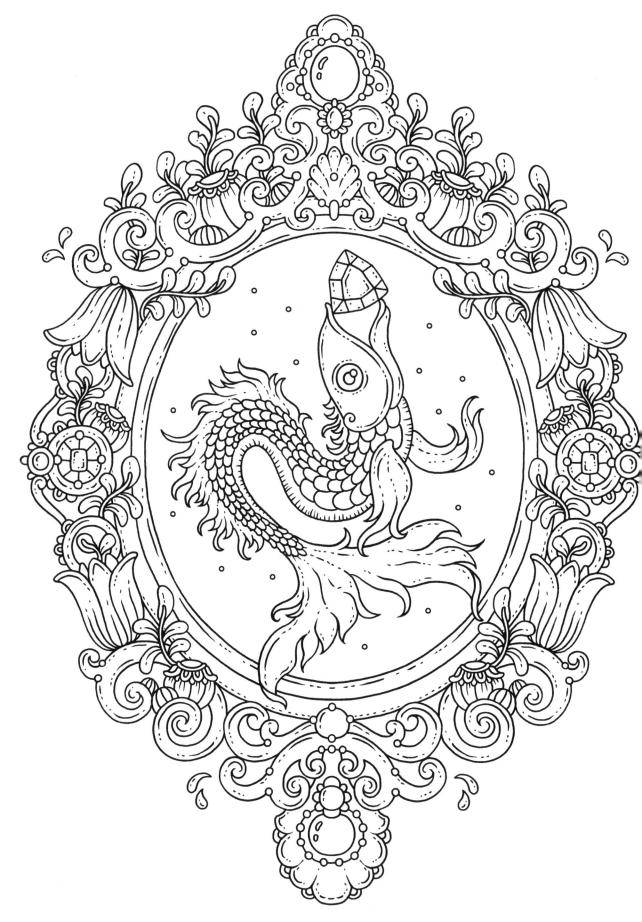

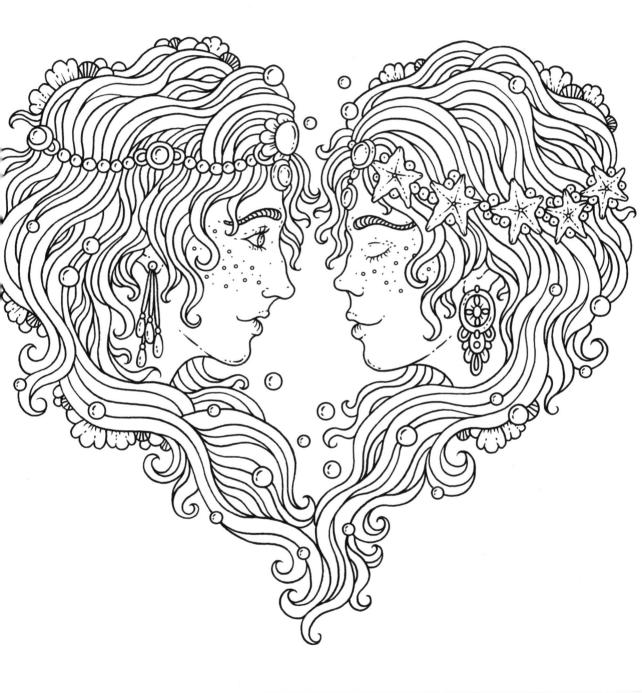

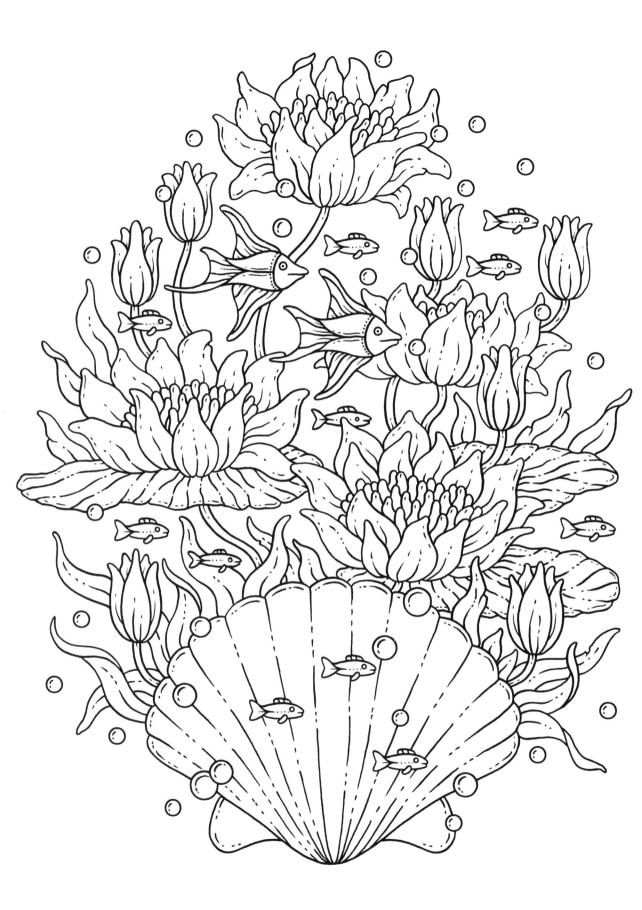

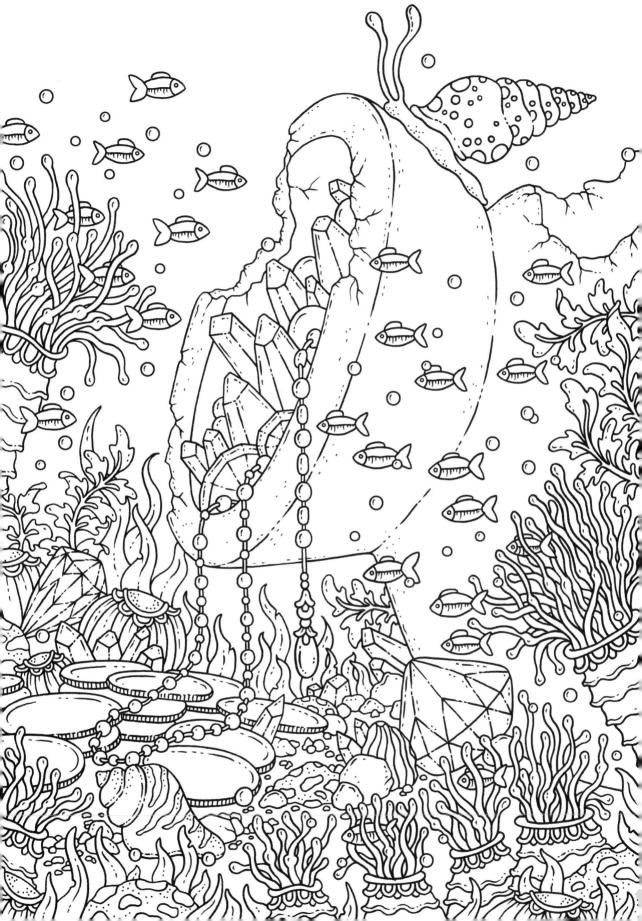

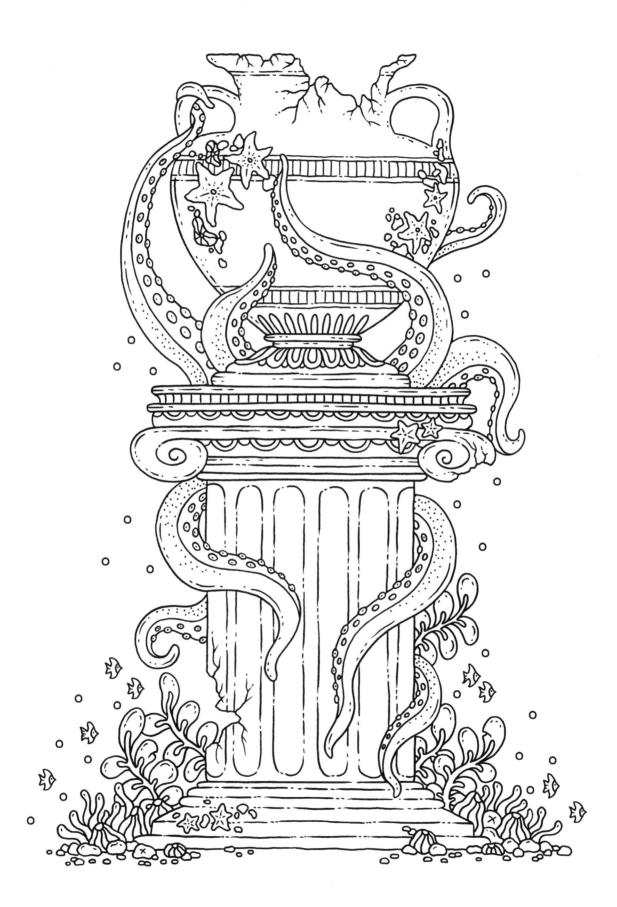

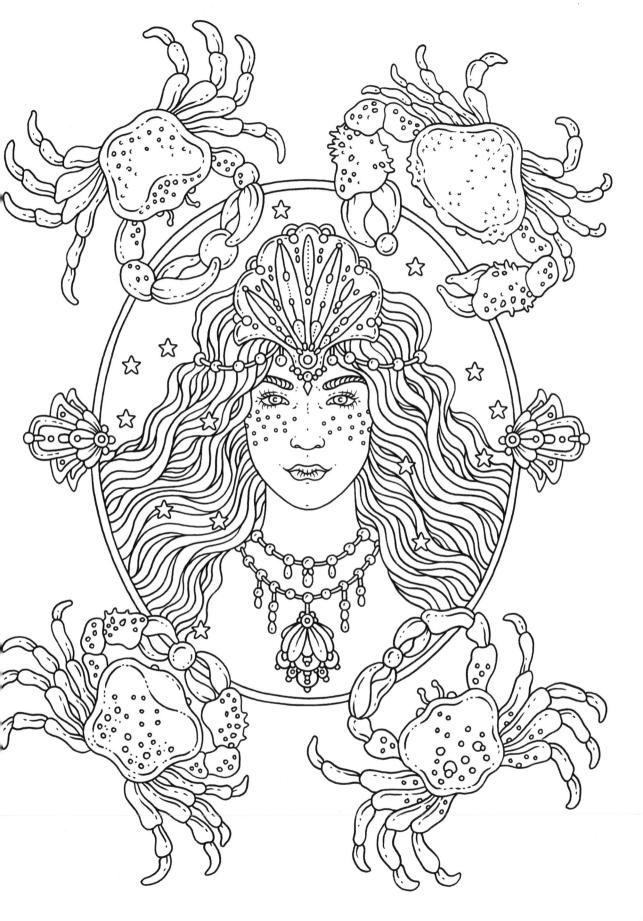

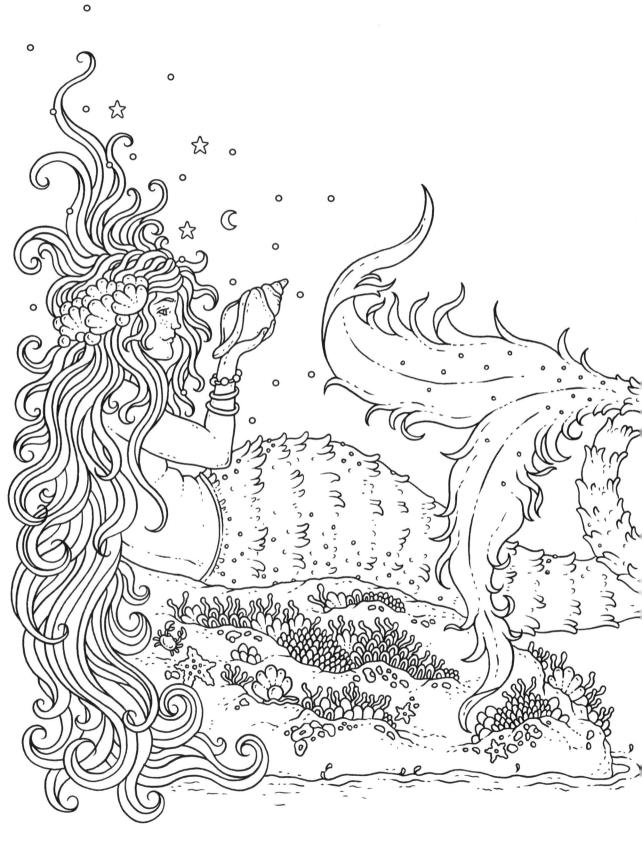

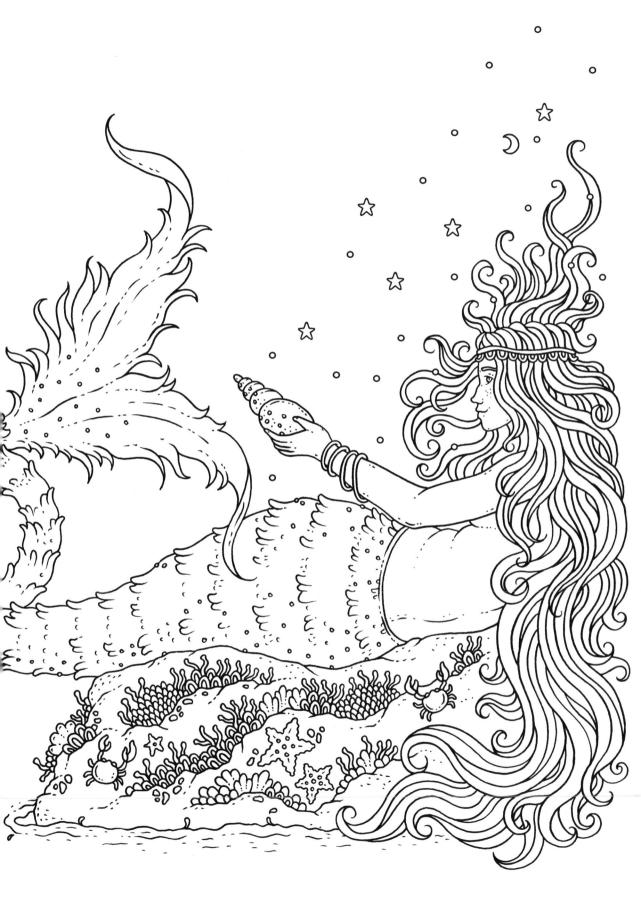

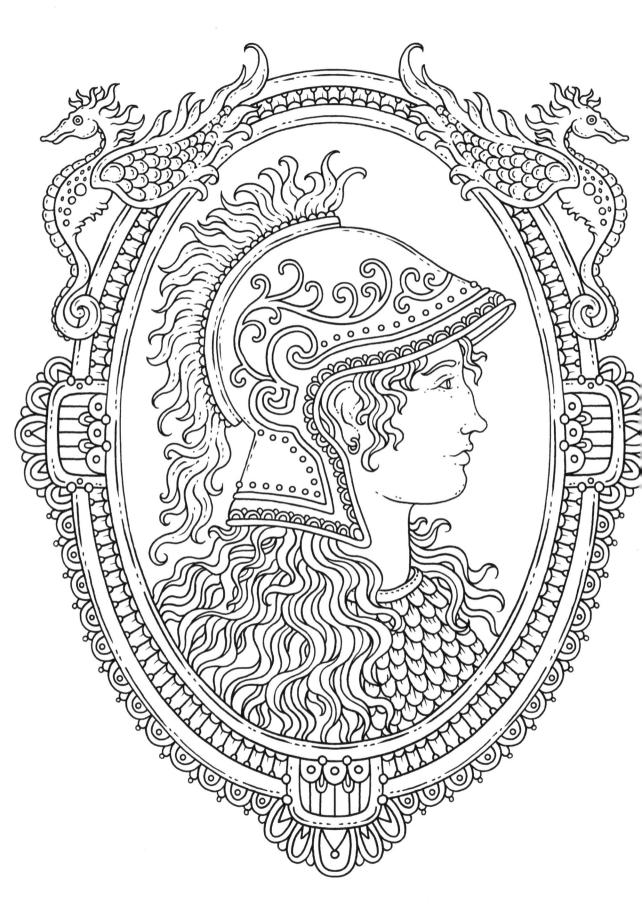

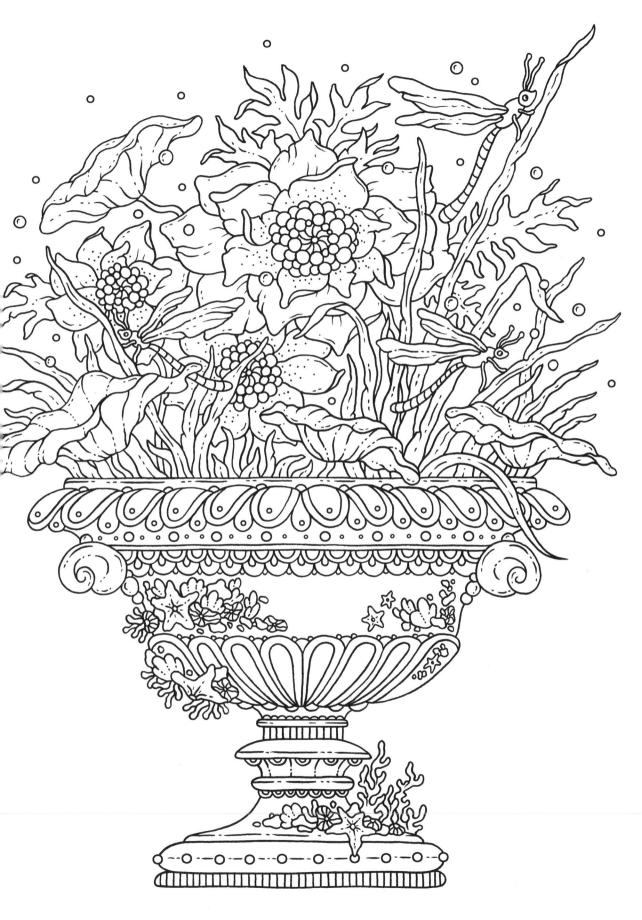

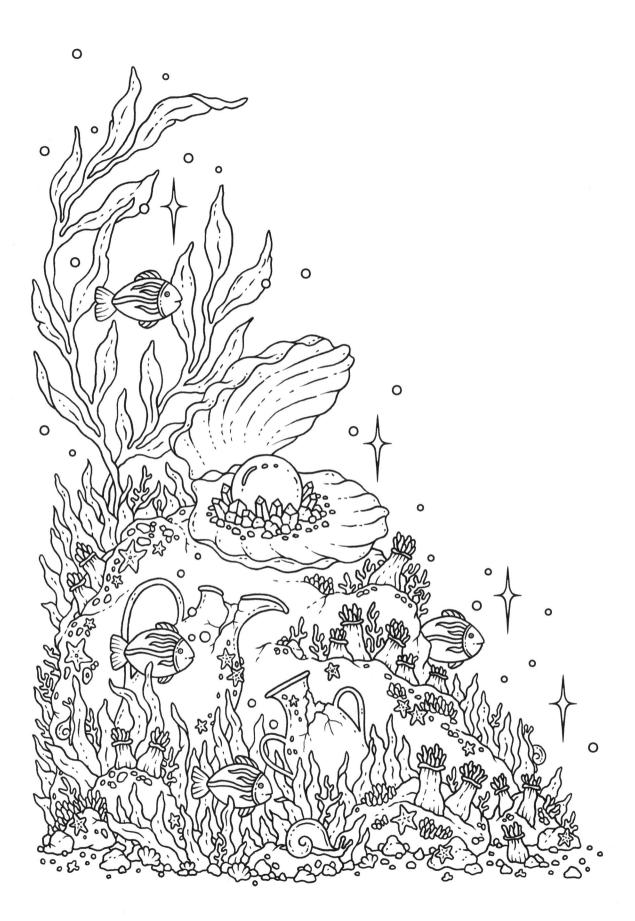

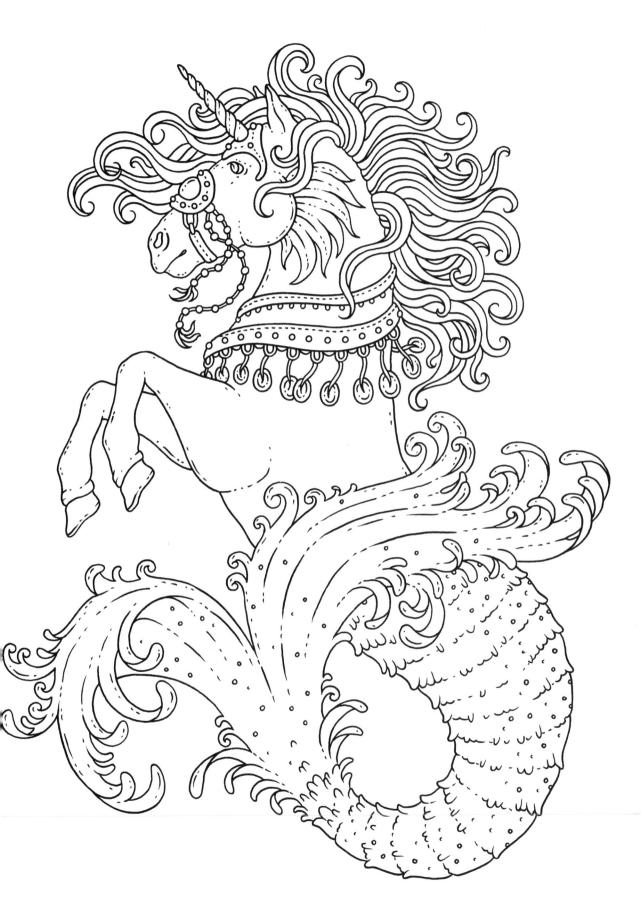

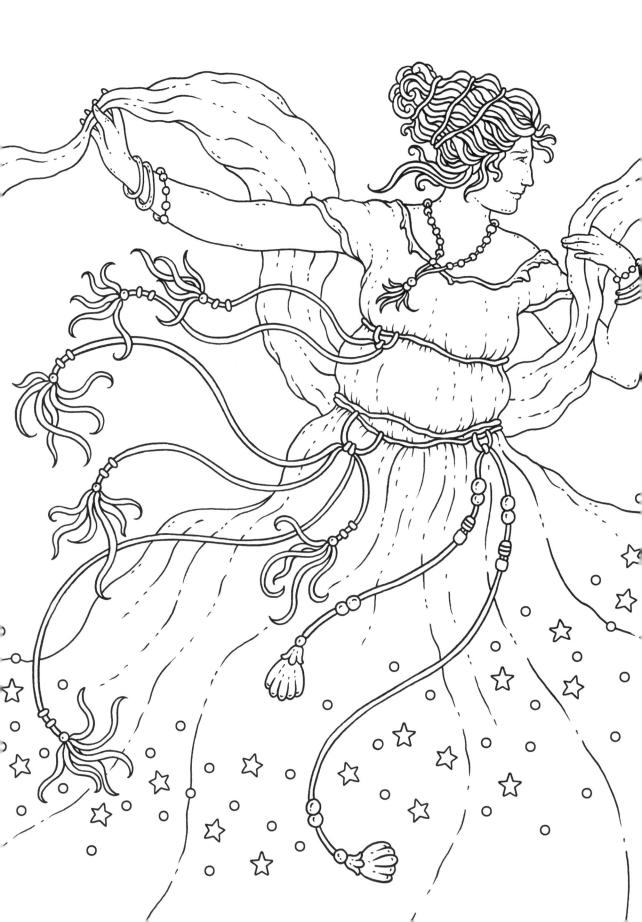

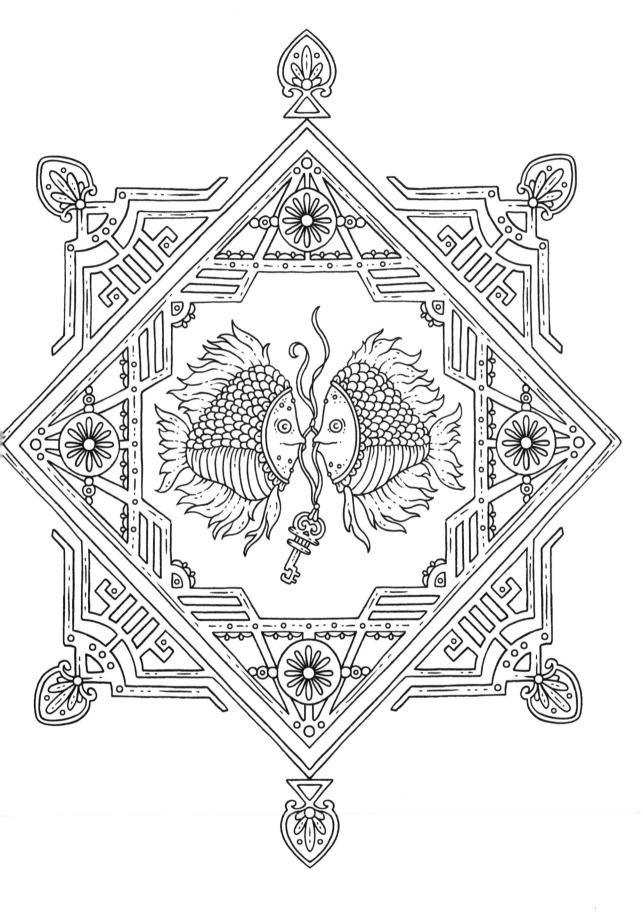

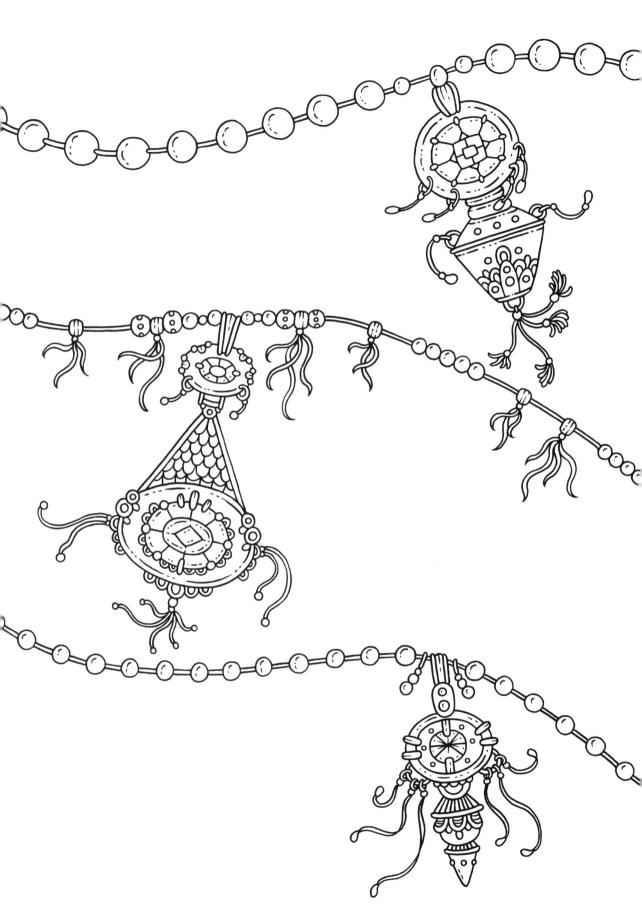

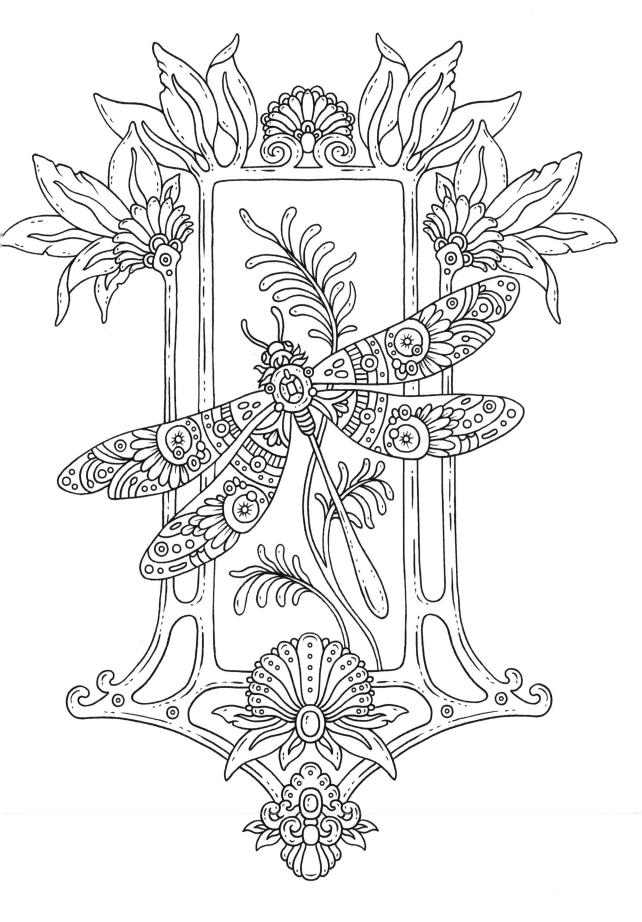

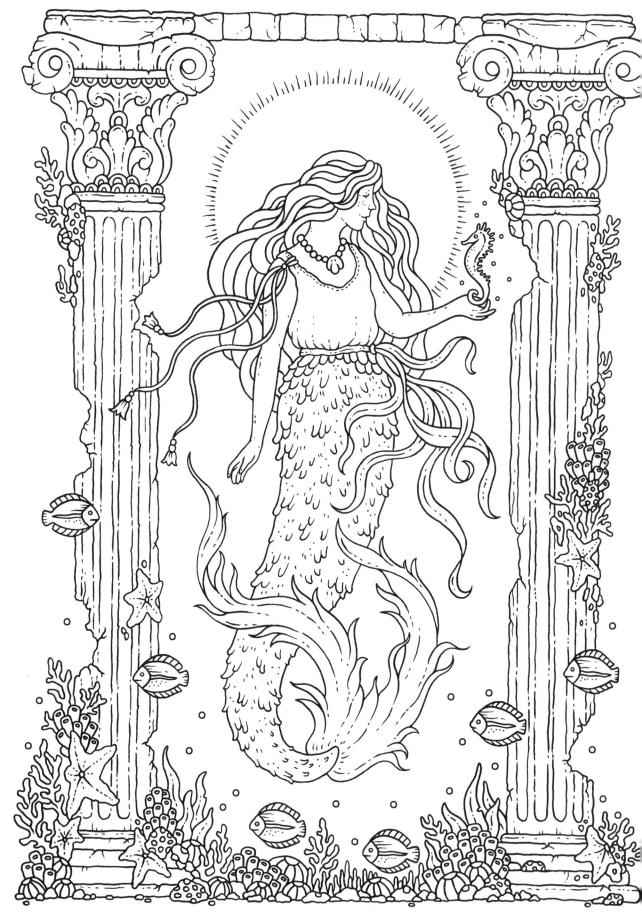

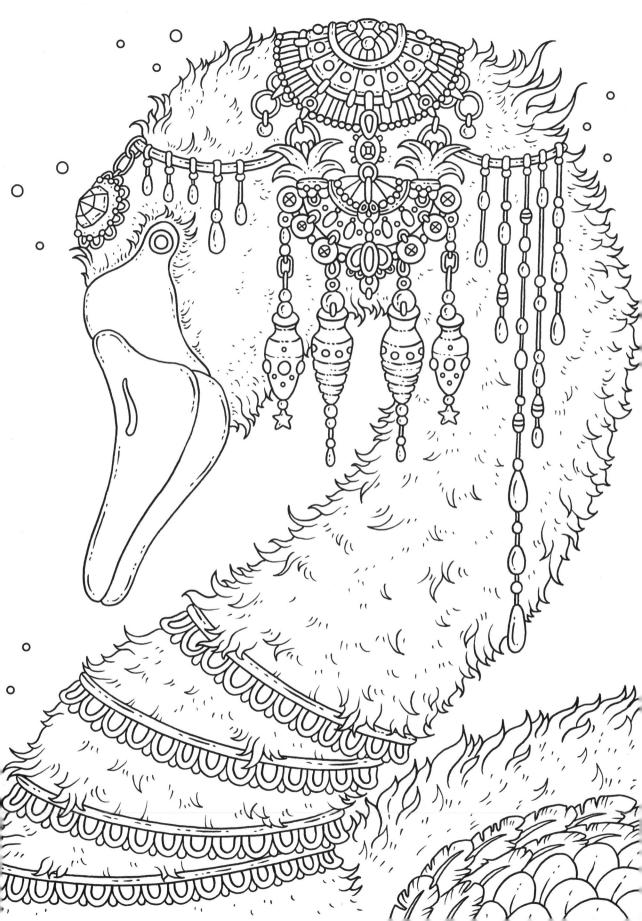

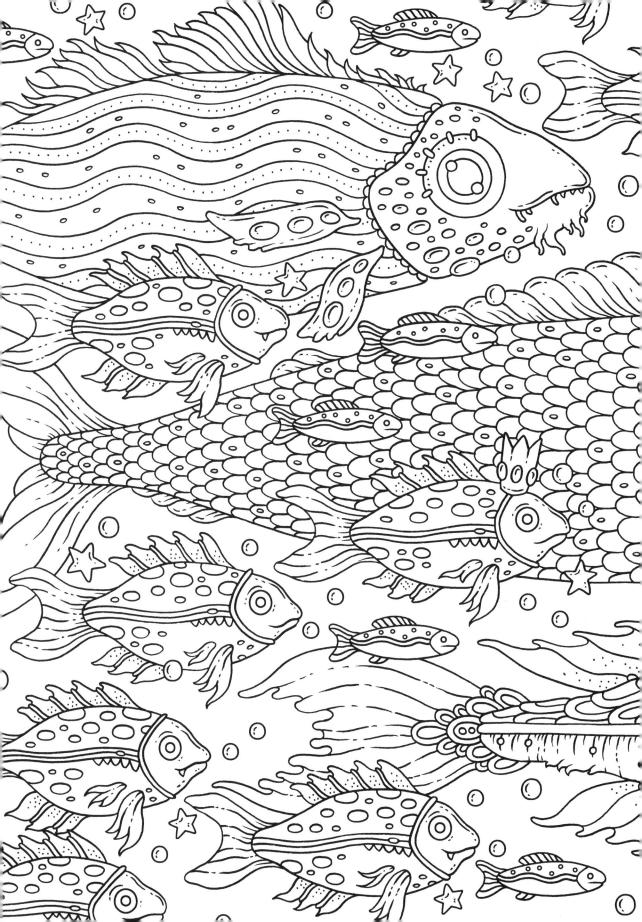

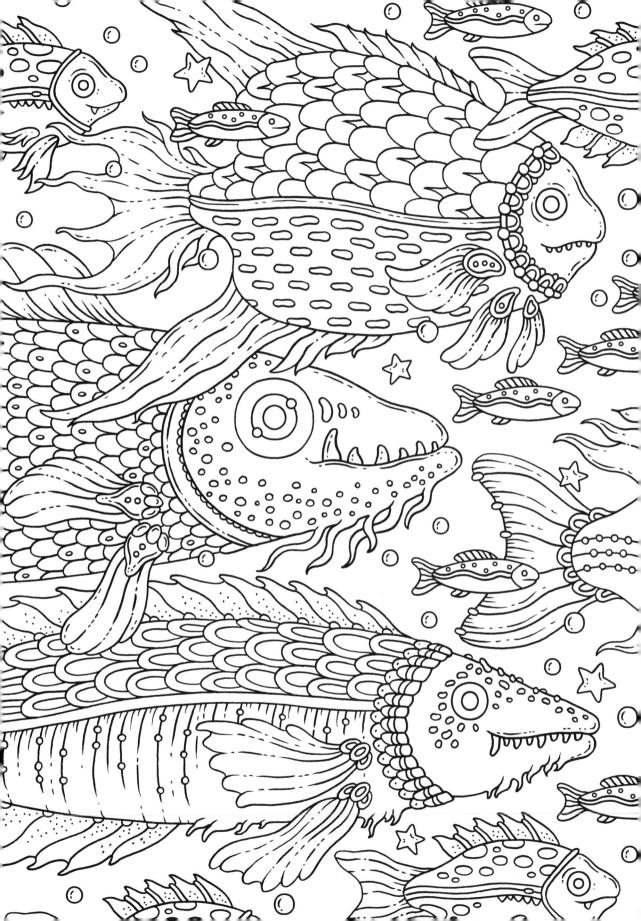

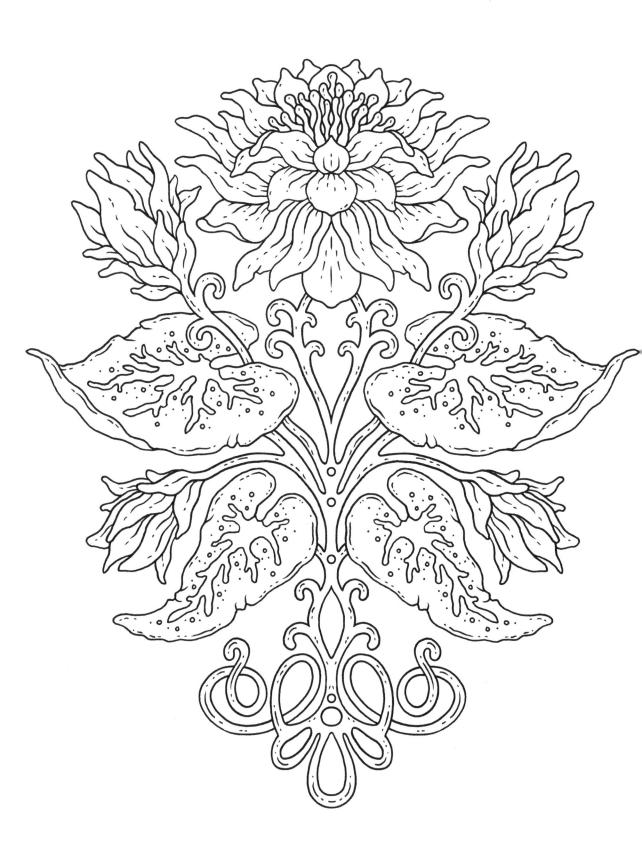

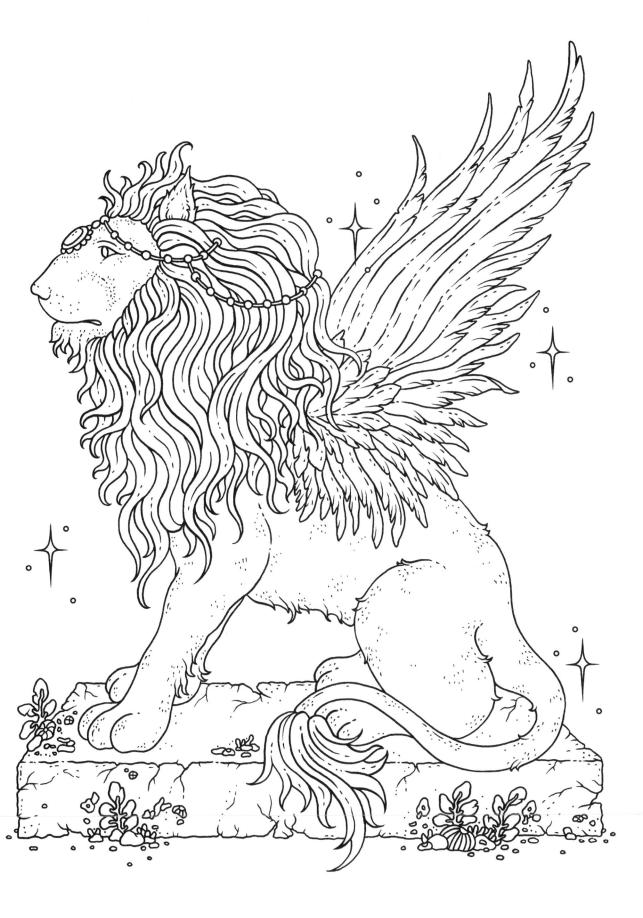

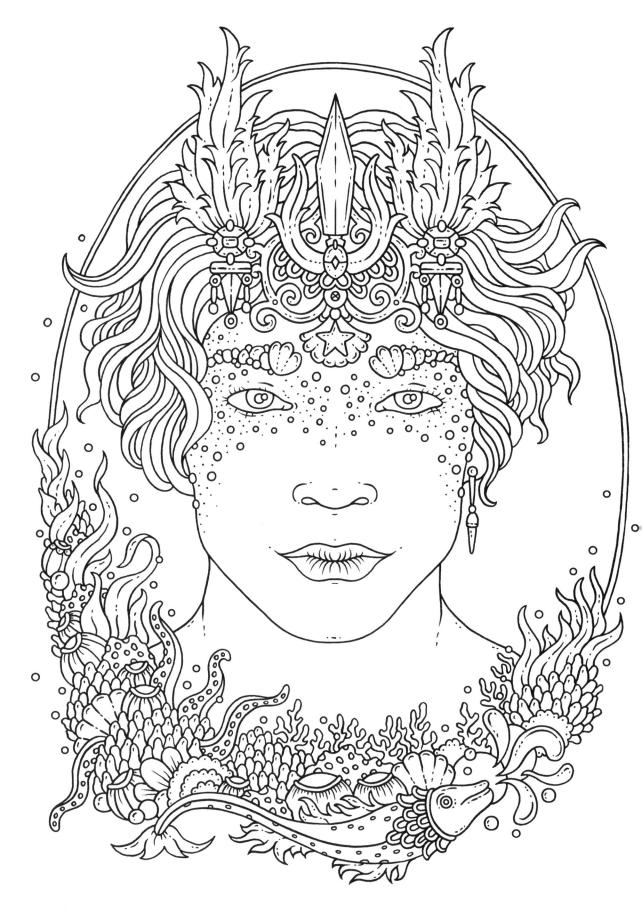

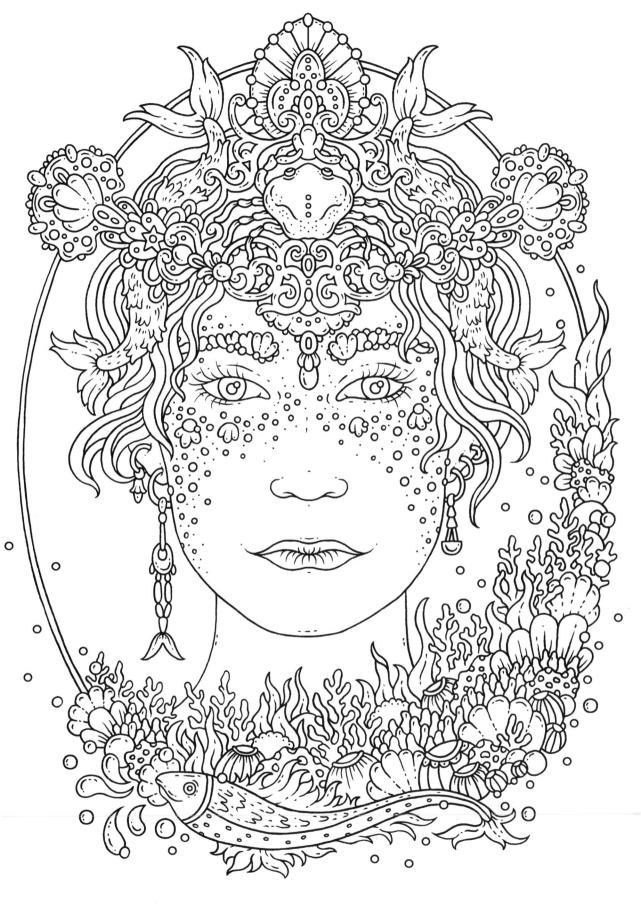

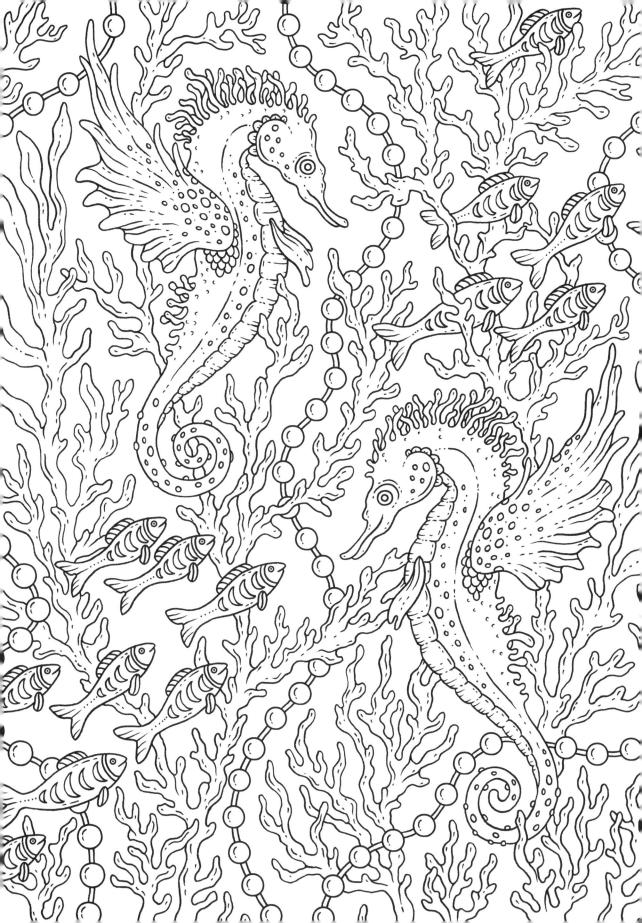

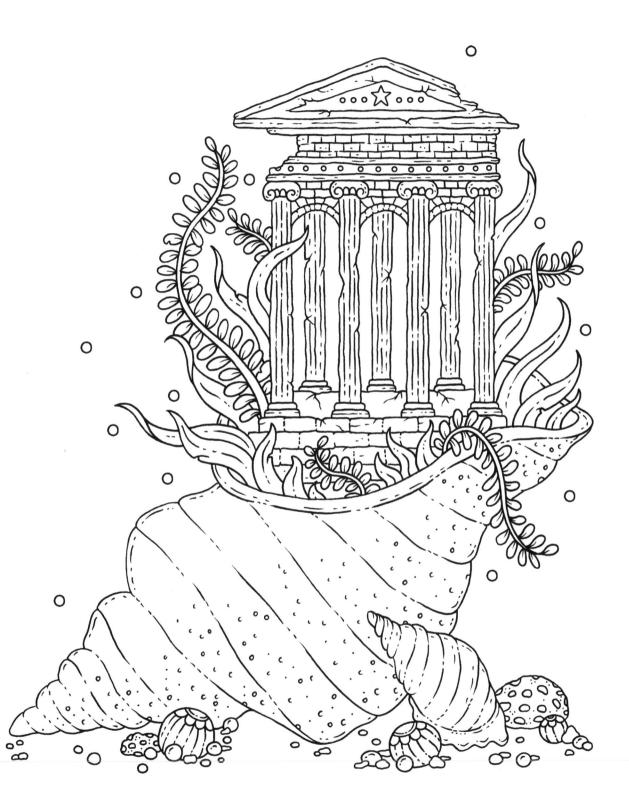

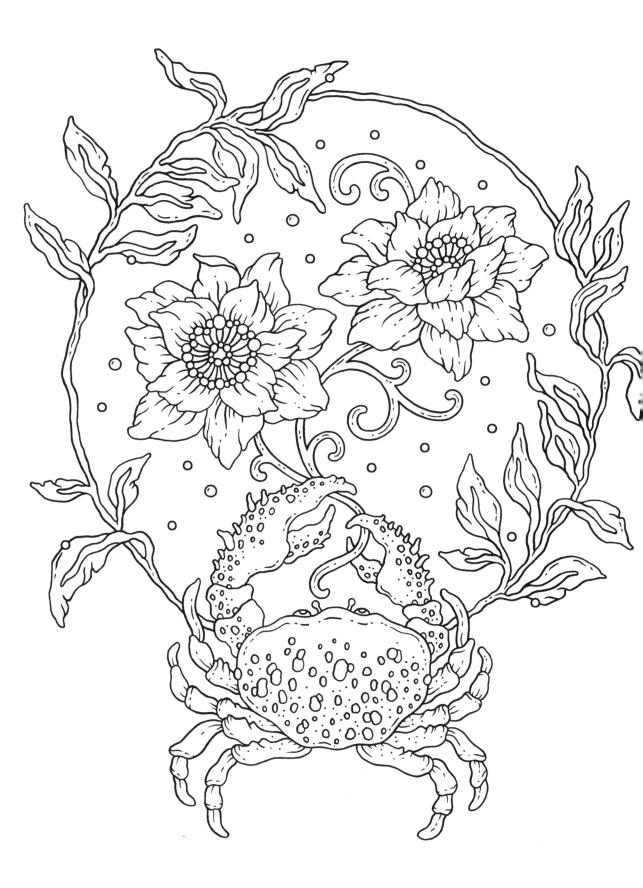

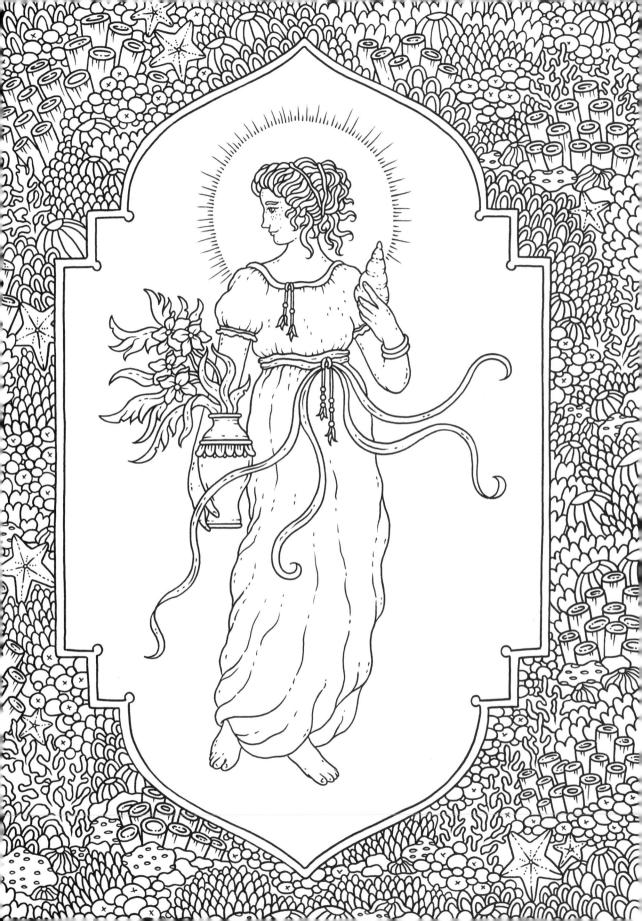

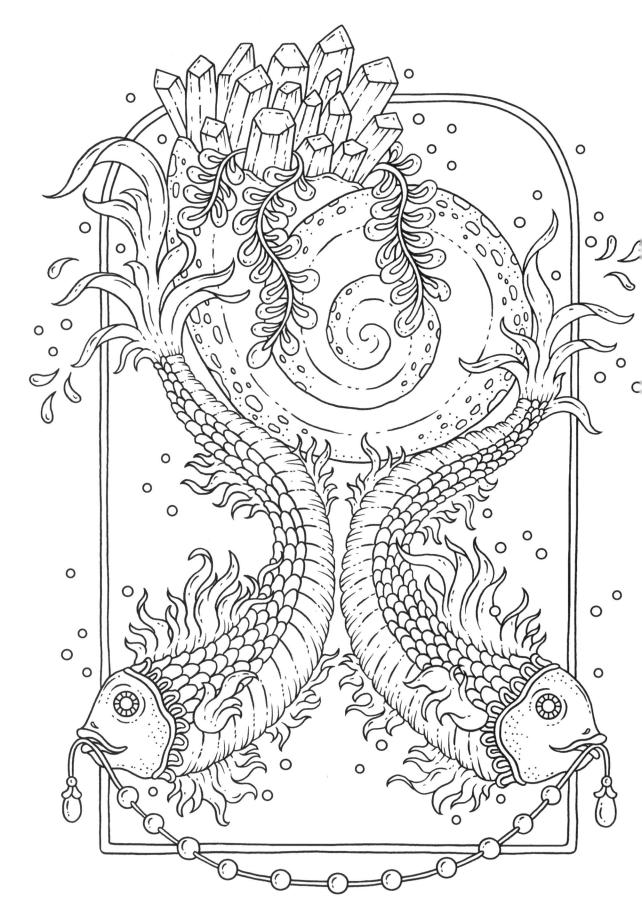

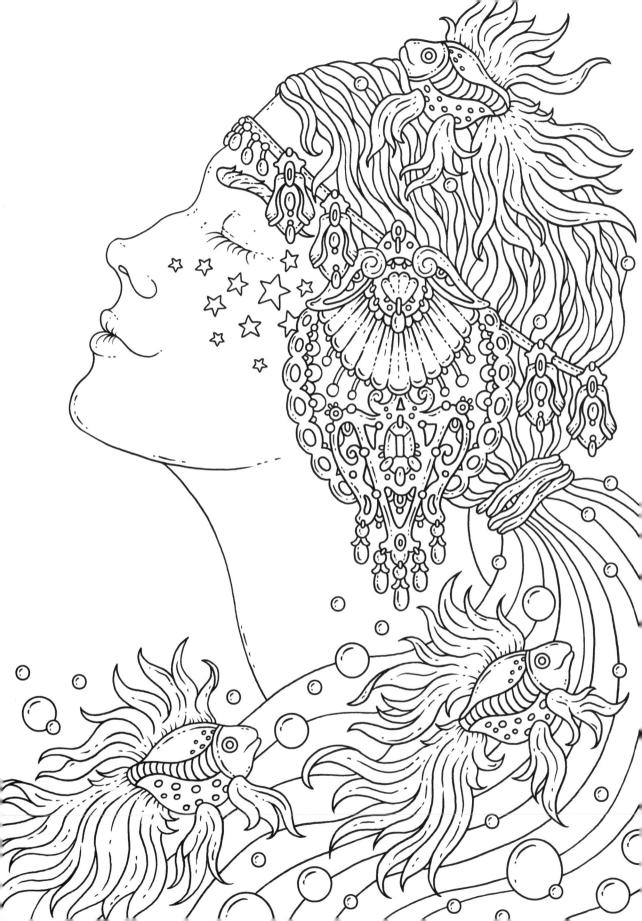

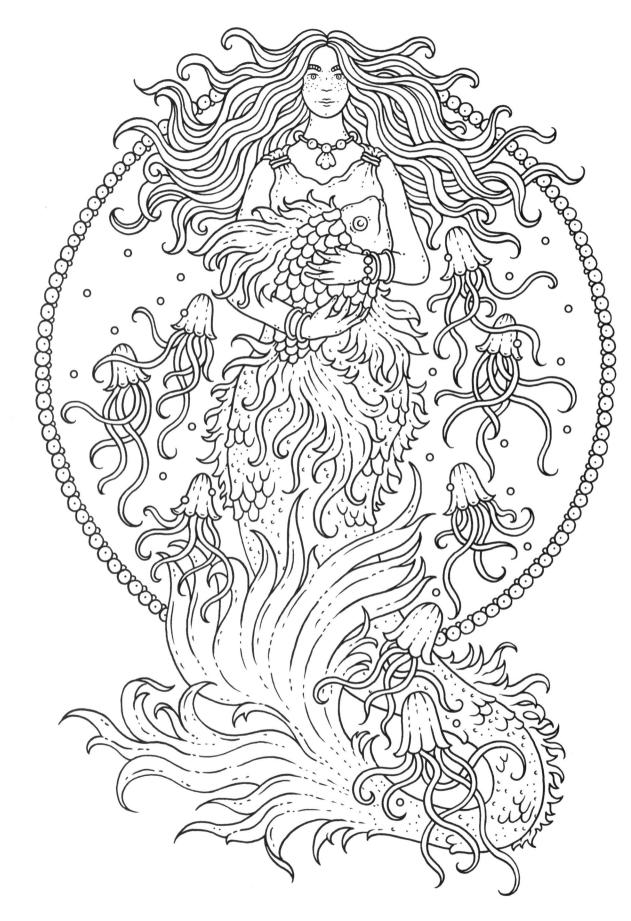

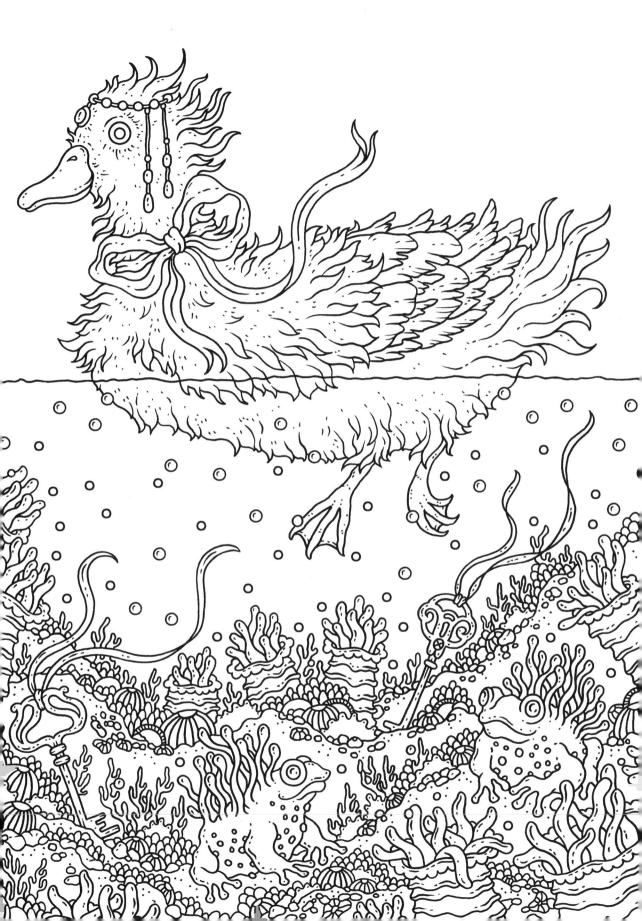

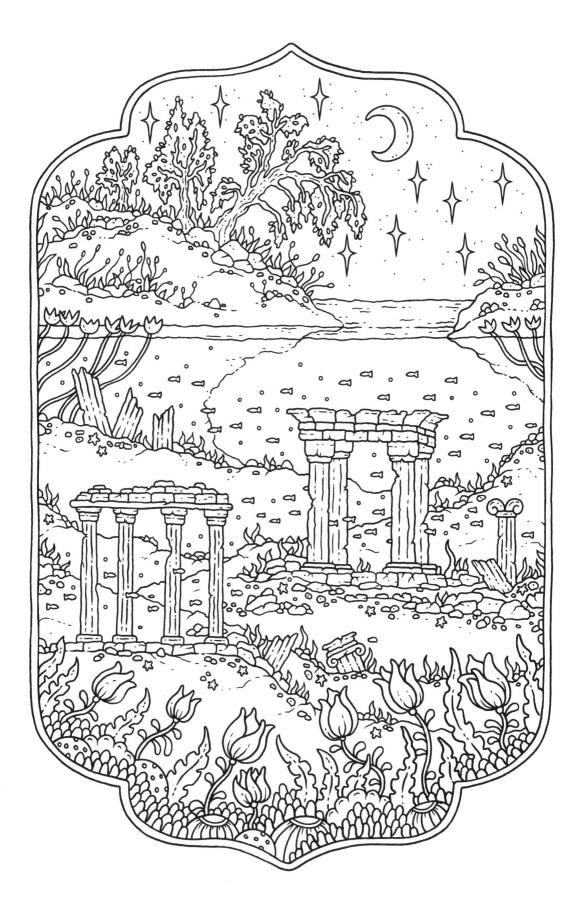

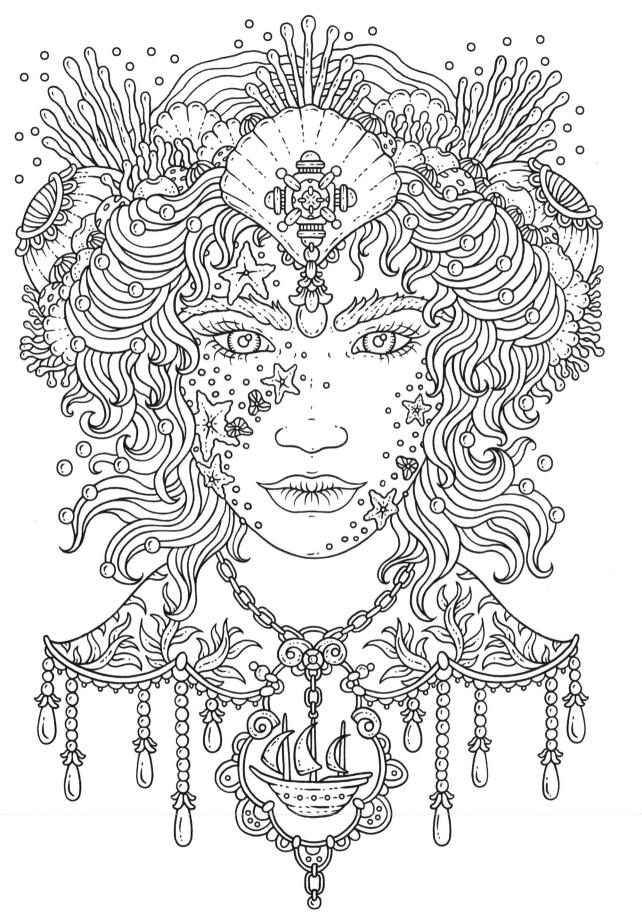

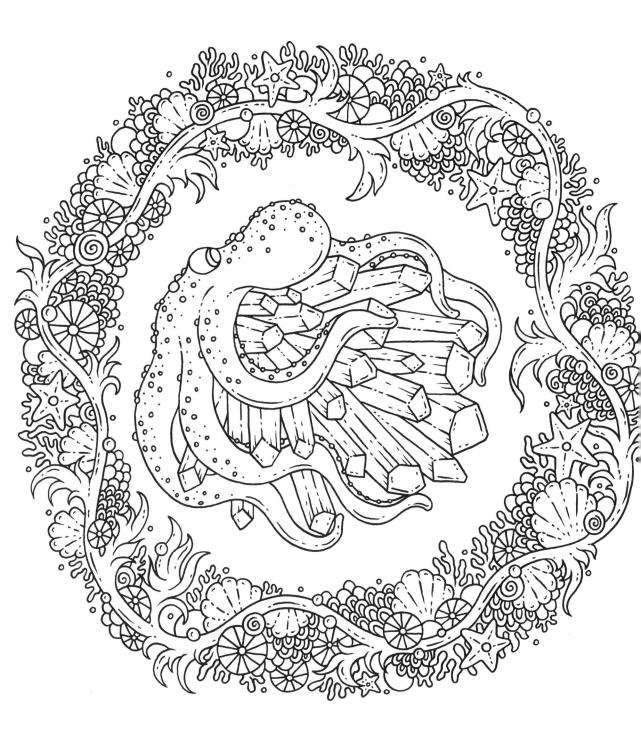

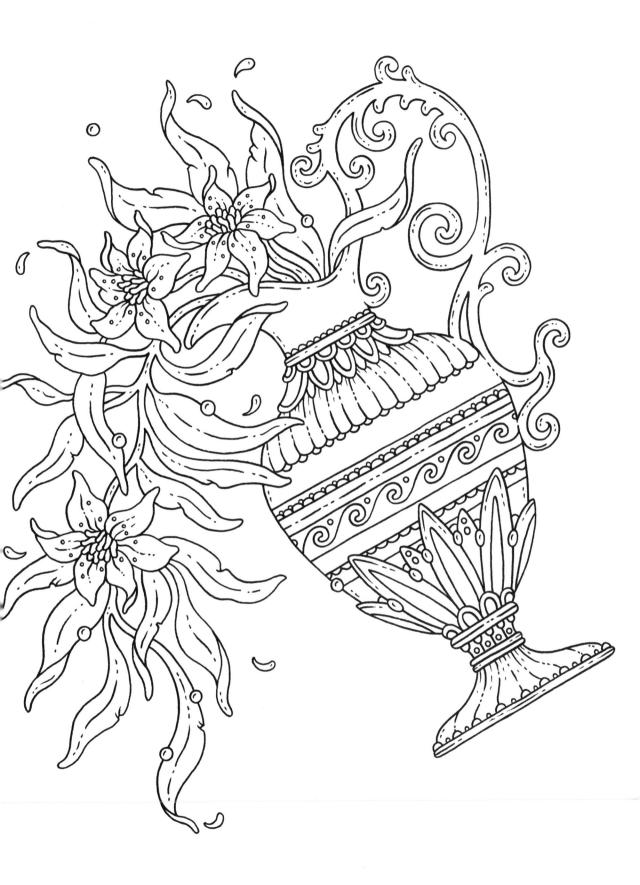

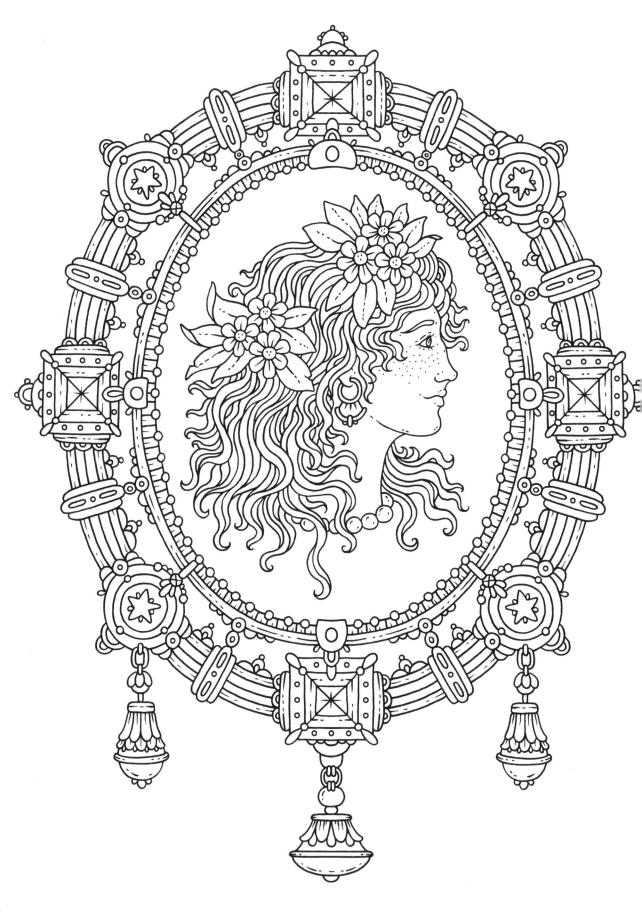

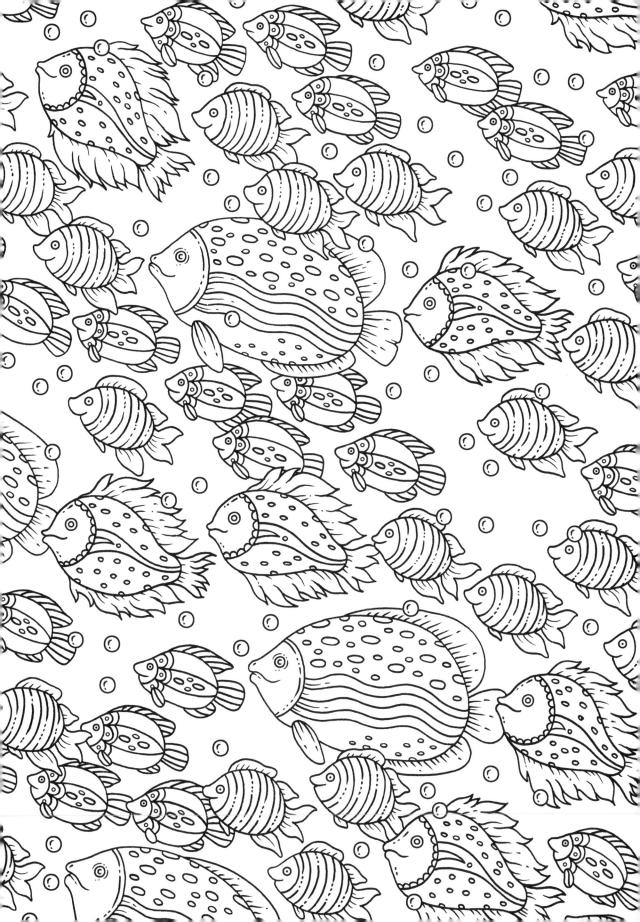

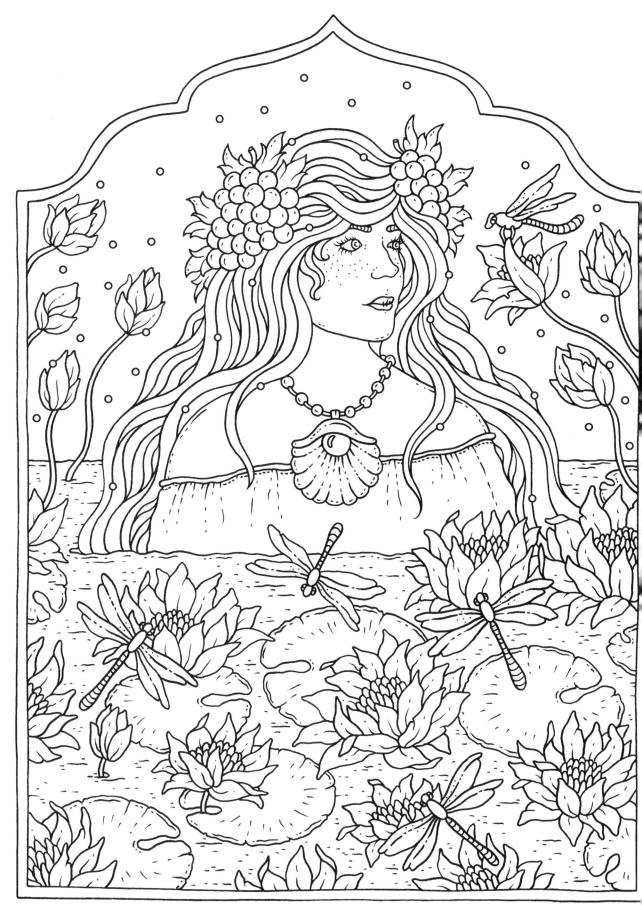

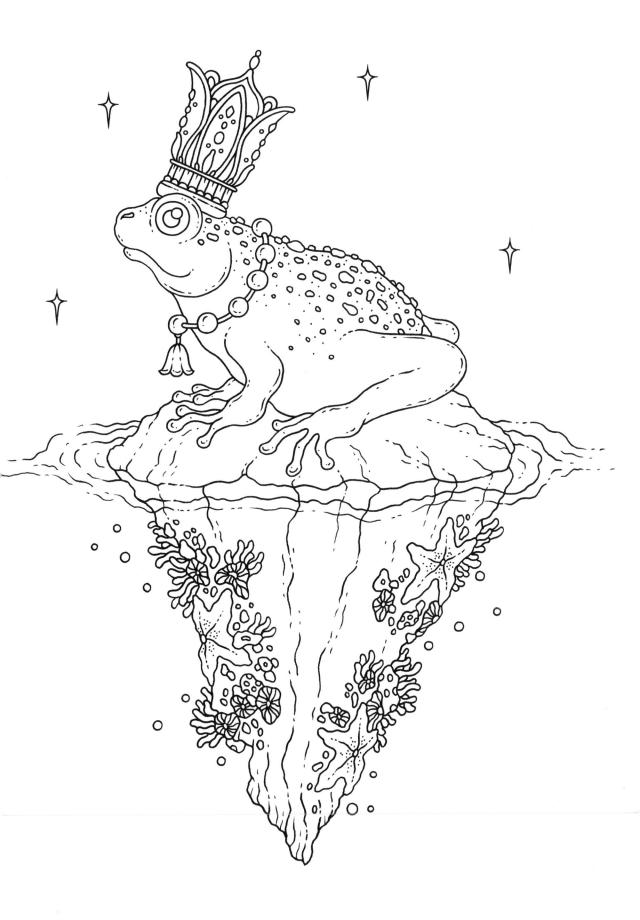

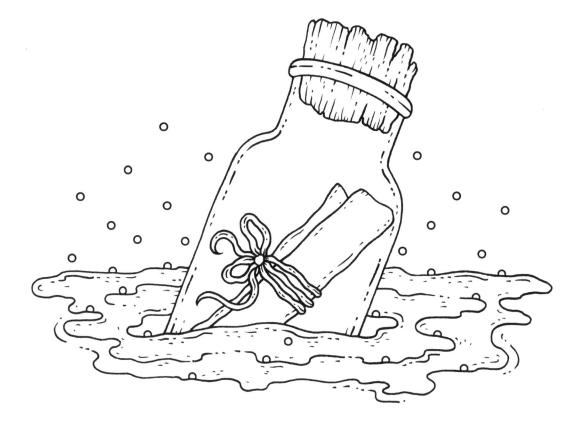